OVER THE
RAINBOW

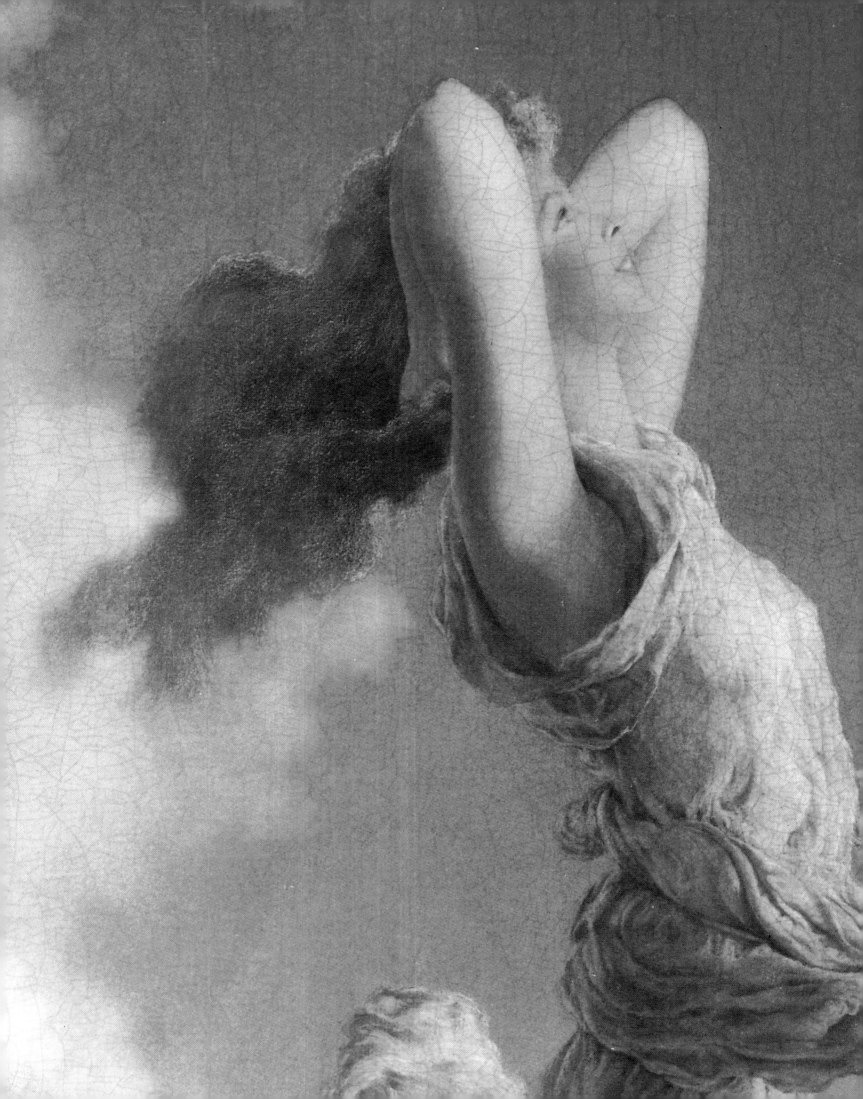

OVER THE RAINBOW

LYRICS BY
E. Y. HARBURG

PAINTINGS BY
MAXFIELD PARRISH

Welcome

NEW YORK

When all the world is a hopeless jumble
and the raindrops tumble all around,

Heaven opens a magic lane.

When all the clouds darken up the skyway,
there's a rainbow to be found,

Leading from your window pane.

To a place behind the sun,
just a step beyond the rain.

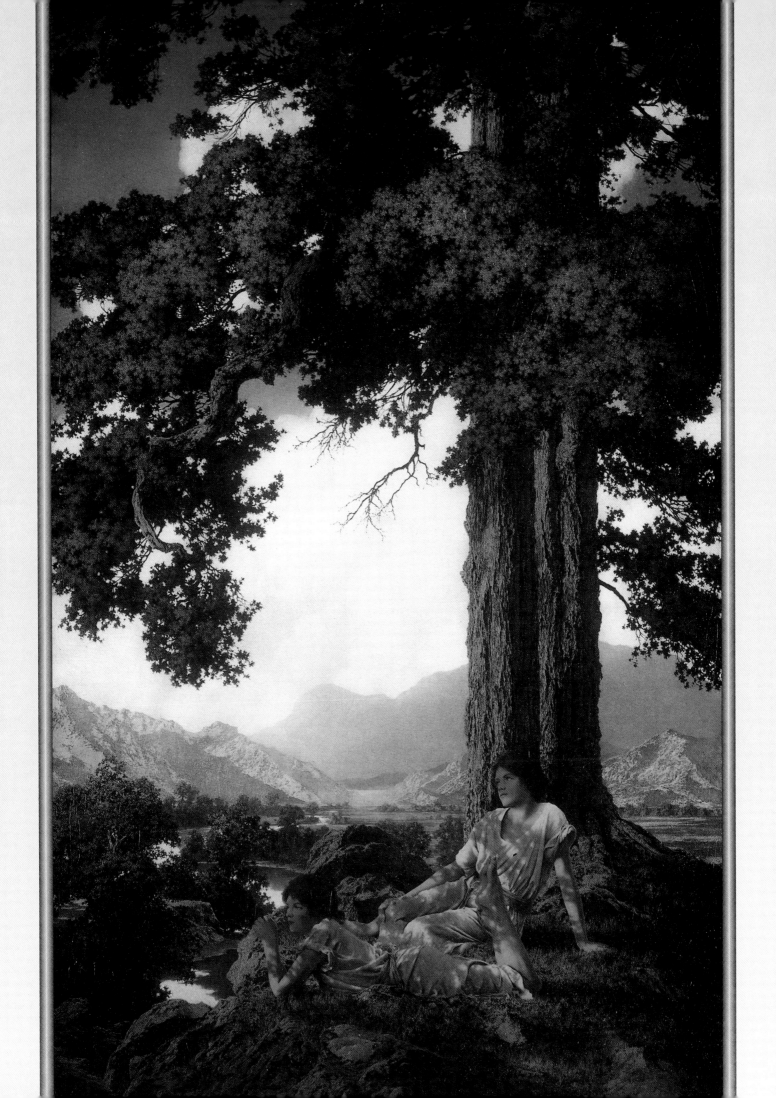

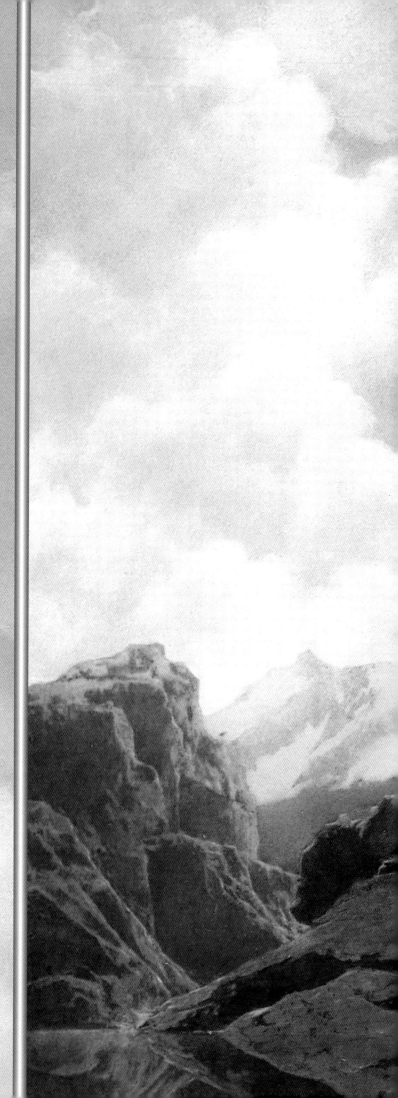

\mathcal{S}OMEWHERE

OVER THE RAINBOW

WAY UP HIGH,

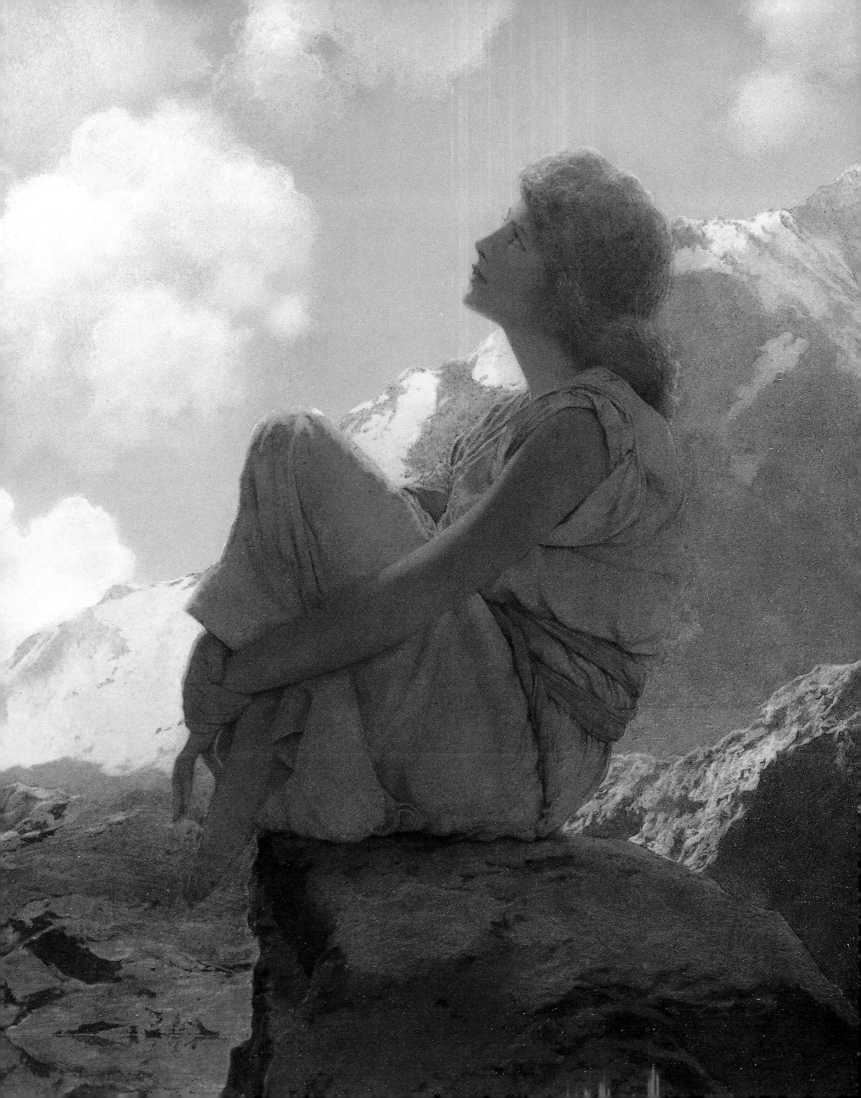

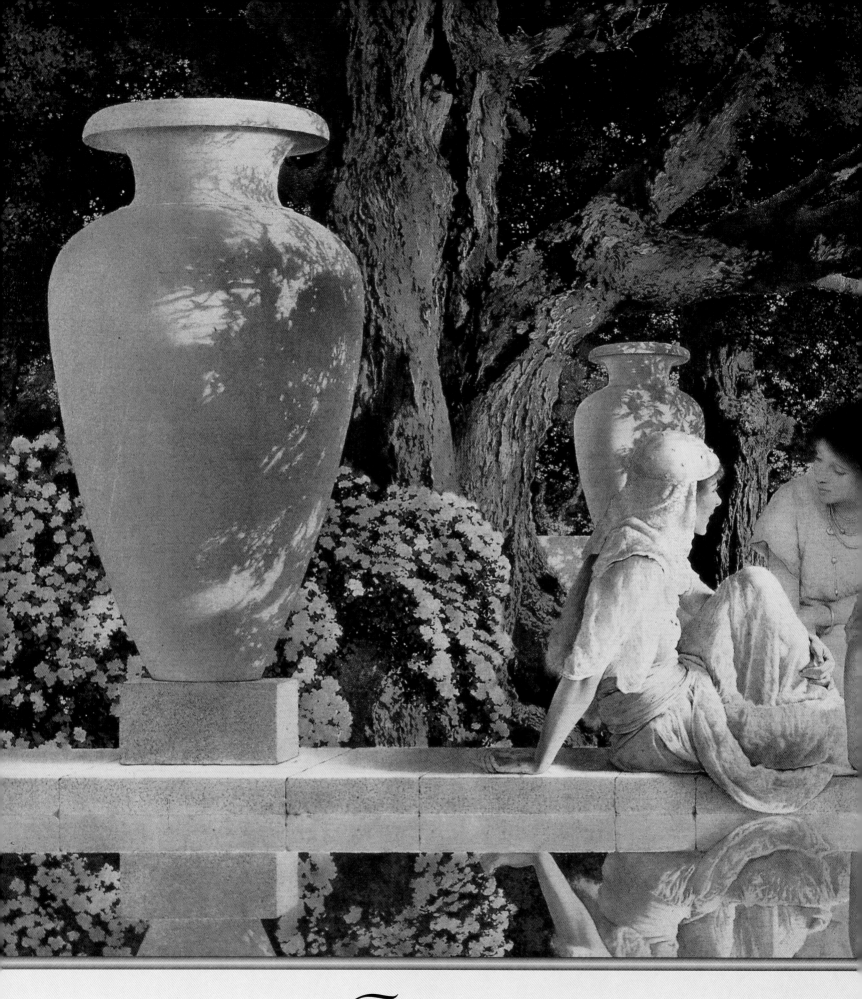

THERE'S A LAND THAT I HEARD OF

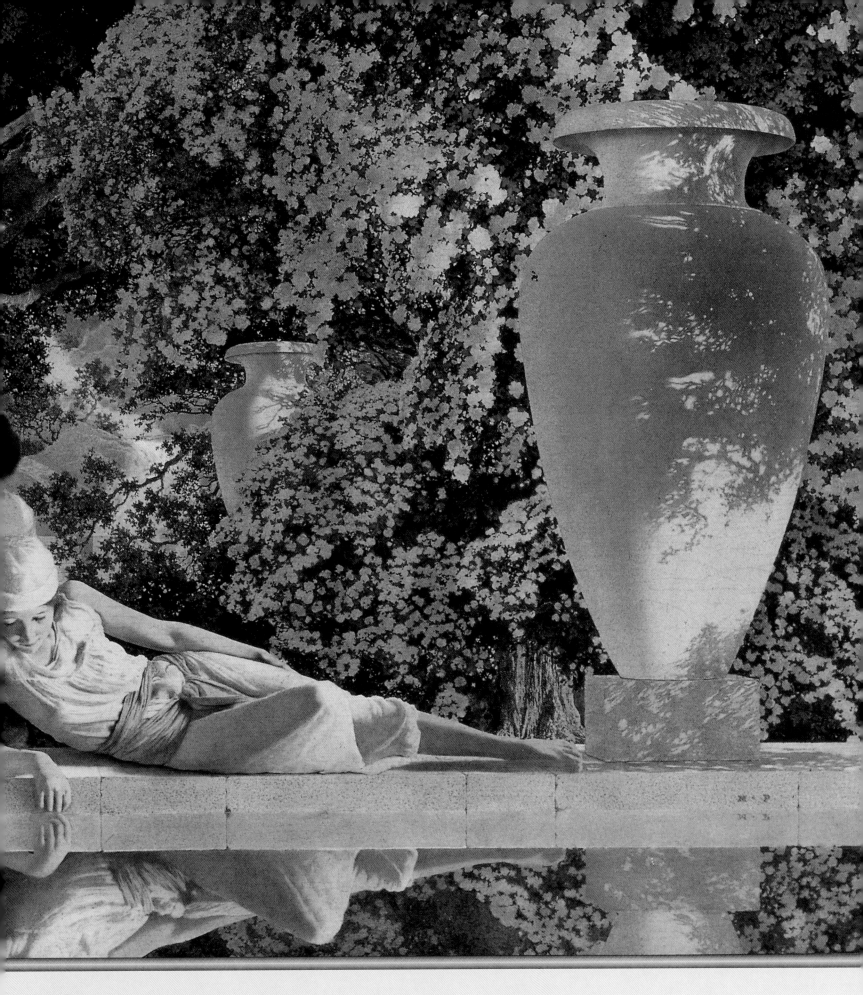

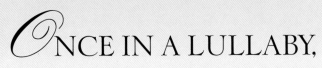
ONCE IN A LULLABY,

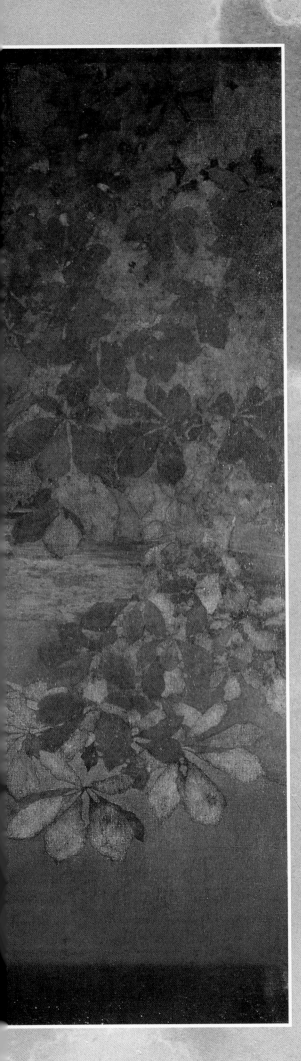

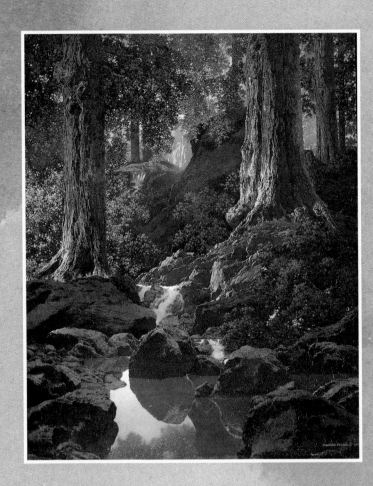

Somewhere over the rainbow

Skies are blue,

\mathcal{A}ND THE DREAMS THAT YOU DARE TO \mathcal{D}REAM

REALLY DO \mathcal{C}OME TRUE.

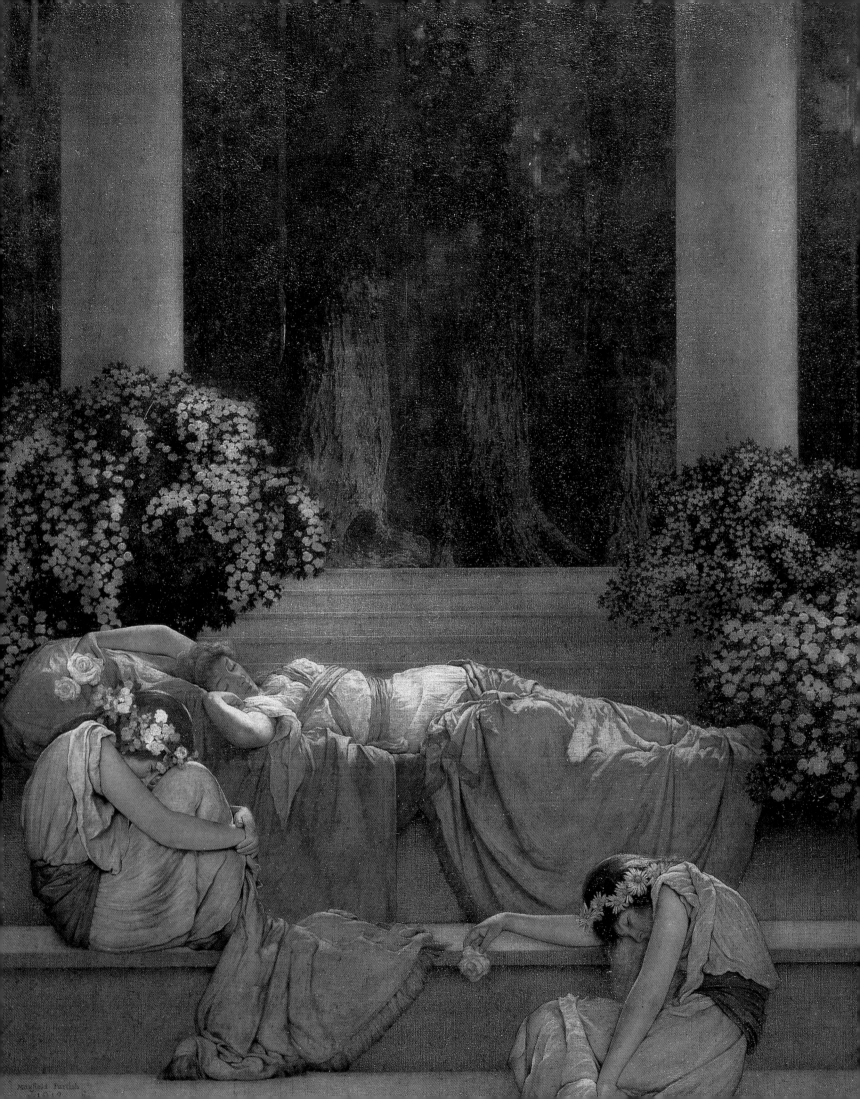

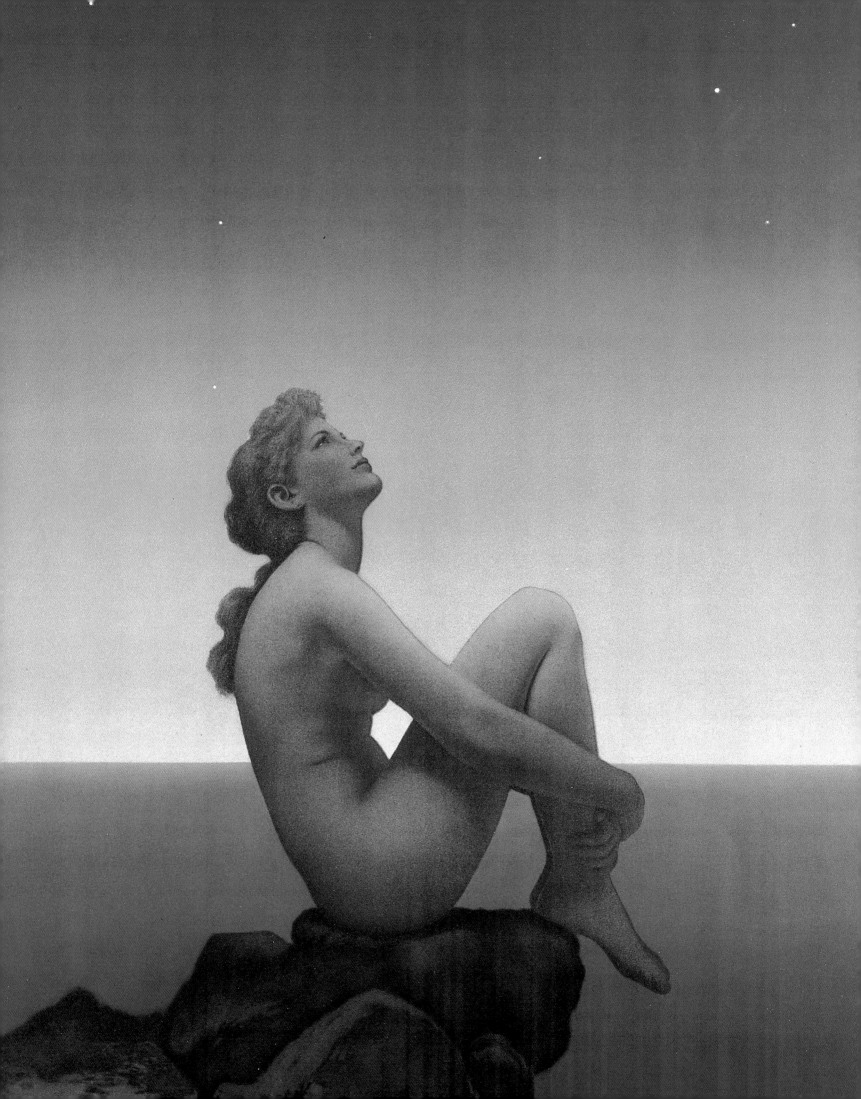

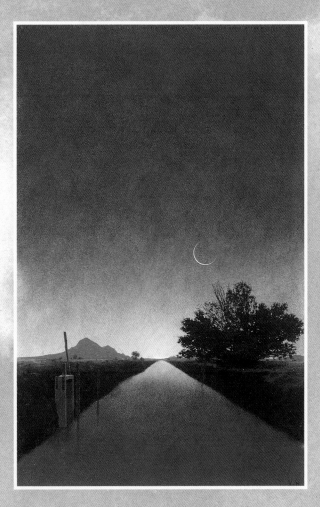

Someday I'll wish upon a star